One has the imagination of one's century, one's culture,
one's generation, one's particular social class, one's decade,
and the imagination of what one reads, but above all one has the
imagination of one's body and of the sex which inhabits it.

Nicole Brossard, *The Aerial Letter*

For Eelco

PAST LIVES

PHOTOGRAPHS BY MARTHA CASANAVE

With Essays by Ted Orland and Lyn Hejinian

David R. Godine, Publisher · Boston

First published in 1991 by
David R. Godine, Publisher
Horticultural Hall
300 Massachusetts Avenue
Boston, Massachusetts 02115

ISBN: 0-87923-872-0
Library of Congress Catalog Card Number: 90-55387

Quotation by Nicole Brossard used by permission of
The Women's Press, Toronto.

First Edition
Printed in the United States of America

CONTENTS

PAST LIVES

An Essay by Ted Orland

PHOTOGRAPHERS, AS INDIVIDUALS, necessarily approach the making of images one by one. But photography, as a medium, demands a higher order of continuity—an intertwining of vision and philosophy that transcends any single image. It's as fundamental as the difference between having an occasional lucky day, and leading a fulfilling life: many photographers have captured a few wonderful pictures, but few can lay claim to even one rich visual *theme*. In *Past Lives*, Martha Casanave offers us five.

From the very beginning, nearly two decades ago, Casanave's central interest has been portraiture. From this core, other themes—nudes, narratives, Russian color and Leningrad winter—have unfolded successively, each empowering a new visual world in which Martha Casanave and her subjects interact in myth or narrative, memory or prophecy.

Of course it's one thing to philosophize about the human condition, and quite another to pay the rent at the end of the month. Martha Casanave is, after all, a working photographer: many of her portrait sittings began as *jobs*. Often, Casanave begins by arranging her subjects against the simplest of backdrops, allowing complexity to build by pairing more than one person within the frame. The result is a tension of particulars —expression, gesture, detail—that becomes the source of delicate intrigues, sparkling with humor and nuance. Witness the dual portrait of Henry and Masha Elinson, a picture deceptively simple in factual description: The father stands in wrinkled workclothes, gazing out with weary bewilderment, while his daughter turns and braces her back against him.

Yet this is more than just a photograph of two people: it is also a photograph *about* them—about their separate worlds, and the space between them. It's as simple, or complex, as the difference between facts and ideas. We sense (intuitively at first) the daughter turning away from her father—that ageless play of the younger generation leaving the old—and beneath that, faintly, the undercurrent of Masha's imminent coming of age, and her heightened awareness of being a woman. But only afterwards, with conscious effort, can we reconstruct the hand of the artist arranging each small detail—like the proverbial (unlit) lightbulb above the father's head, or the tenseness in the daughter's grip that keeps her from falling back against him—that leads us to those truths.

In 1982, building upon the emotional richness of such portraits (while paring further their already sparse

compositional framework), Casanave introduced a new series utilizing the nude figure. Though obviously not candid, neither do these pictures seem posed; rather, one has a sense of fleeting gesture and stance caught *en passant*. Picture a woman photographed leaning into strong sunlight, her thin, muscular body thrusting forward—fist clinched— in taut challenge to the surrounding world. No longer photographs of *individuals*— there is no eye contact, and even faces are rarely identifiable—they become studies of gender, of character revealed through the body alone.

But consider it a small perversity of the profession that the artist can rarely pause for long to savor the resolution of an artistic issue. To survive, the artwork must continually change with the evolving consciousness of maker and viewer. In *Narratives*, begun in 1984, Martha takes aim anew upon issues central to her own life. Compared to *Portraits*, these pictures speak less of others' experiences than of her own. And in dark counterpoint to *Nudes*, they speak less of gender than of gender *roles*.

Generated from a deep emotional ground, these narratives are often singularly grim in their assessment of the roles assigned women in our society. Envision, for instance, a woman looking into a room from a slightly open hallway door; in the room a man leans over another young woman lying below him unclothed. Possibly, if asked to stage a scene matching that outline, the male psyche would drift toward issues of voyeurism or eroticism. From Casanave's perspective, the issues are infinitely more chilling. The room is shabby; the man wears a clinician's coat; the woman's body sprawls awkwardly on a table draped with a wrinkled white sheet. Fear stalks us. What has happened here? And what fate awaits the next woman?

In another photograph, equally ominous, a man stands directly beneath a single spotlight in an otherwise darkened room. He confronts us with casual arrogance, his head thrown back just enough to reveal a cruelty in the turn of his mouth, while his eye sockets remain empty black holes. Ten steps behind him an anonymous figure in a wedding dress drifts uncertainly, while darkness envelops her. And thus another woman disappears.

Pressed for details, Casanave will likely tell you only that *Narratives* represents exactly that: experiences common to herself and other women. The issues raised, however, touch us all. Photographed with a detail-obscuring pinhole camera, the *Narratives* blur—both figuratively and literally—the distinction between the actual and the apocryphal, between memory and prophecy. Taken together, they form a twentieth century mythology. And were you to ask, as you might of the classical Greek tragedies, *But is this story really true?*, you'd get back the same answer: *It is now*.

Recently, Martha Casanave's long journey from the particular to the universal may have reached—in purely photographic terms—the limits of visual resolution. In two recent series, she turns her lens upon the Soviet Union, a world as far removed from our experience as it is close to hers. (Few people realize that Casanave speaks Russian and has travelled extensively in that country on several extended visits since 1968).

In the first series, Casanave returns to the sharp image, focusing (literally) upon the details of Russian life and culture. Using unexpected (and often demonstrably false) color, she opens a door into the Russian psyche, challenging assumptions that decades of cold war stereotyping gave us about the USSR. Often, she tweaks our intellect almost playfully, such as when giving mock-validation to our prejudices with scenes of blood-red canals and thermonuclear skies, or postulating an underground world of psychedelic color flourishing just behind the ubiquitous gray facades of Russian cities.

But in other images, the harsher realities of Russian history are brought home to us. In one close-up, Casanave approaches a statue that was heavily damaged during the siege of Leningrad in World War II, and transmutes it to living color: the marble body rendered as flesh, bullet holes as wounds, shrapnel scars as physical abuse. No longer just another classical Greek sculpture, *Mother Russia*—Casanave's working title for the image—stares into the distance through tear-stained eyes, her expression a haunting reminder of the terrors the Russian populace endured in that war.

In her second Russian series (begun in 1987), Casanave carries us to the opposite visual extreme, renouncing both color and detail as she reverts to the soft-focus pinhole camera used previously in *Narratives*. This time, however, the icy whiteness of the Russian winter further simplifies the composition until we strain to identify even the most basic shapes—a sphere, a person, a street, a river.

The only details, in fact, that appear are the prints' titles, which are curiously specific—compare the pale image of a large fuzzy building with its title, *House Where Dostoevsky Was Arrested, Voznesensky Prospect;* or a row of wispy silhouettes to their title, *Leaning Trees, Mikhailovsky Garden.* Clearly these pictures could as easily represent, without visual contradiction, a thousand other neighborhoods, a thousand other forests— perhaps even, secretly, places that already seem familiar to you. In *Leningrad Winter* the day-to-day world recedes until, finally, only archetypal forms persist, floating to the surface of the silver paper like fragments from a long-forgotten dream. Like faint traces of memory from a past life.

PAST LIGHTS

An Essay by Lyn Hejinian

IF, AS MARTHA CASANAVE HAS SAID, a photograph is always taken of what, within seconds, has become a part of a past life, then a photograph might be both descriptive and elegaic, a record of the scene seen and the memento of it. Both description and memory are projections of the imagination; both impose a version of the past on other possible versions of what has occurred. But versions of the past are also understandings of it, and they are thus its present life, and possible motifs for its future.

Far from presenting an arrested moment of time, Martha Casanave's photographs represent a shimmering of time. The very instability of our perceptions (and of the camera's) makes the present radiant within the past without either being effaced. And our miraculous inability to arrest either the past or the present results in a potentially infinite series of impressions, one within another, in processes which are expansive with transformation and unpredictability.

Meaning is a relationship between the perceptual imagination and reality, or, as one could say in the case of these photographs, between art and life. That the relationship is an unstable one is an indication that neither art nor reality is complete, and so we find ourselves in a perceptual field that is constantly changing and always only partially seen. Meaning, too, as in Martha Casanave's photographs, is a relationship between the mind, with its emotional intellect, and the body, which stands around and before it.

One can't capture the world with images. But the relationship of a picture to a place, and the process whereby the picture-maker establishes such a relationship, are exemplary of our ceaseless and perpetually partial involvement with the process of making meaning, and of making our experiences meaningful.

Notably, much that I would say about photographs is applicable to my experiences of visiting the Soviet Union and Soviet friends and colleagues, though the context of my visits has been literary, connected to my work as a poet and translator. My medium of interpretation, thus, has been linguistic. An American artist's travels in the Soviet Union offer, in a peculiar way, a quintessential experience of the ambiguities inherent in a construction of meaning. Russia provides the viewer with its sensorily complicated and dense experiences, in the social landscape of its city streets and apartment interiors, of conversations and confidences, but our understanding of them is perpetually partial and our ultimate enjoyment of them is perpetually deferred. Just as a

child seems to exist in a state of waiting, which is nonetheless active and utterly untentative, so we stand in one reality attentive to another. Being there becomes a process of interpretation, and also of anticipating memory.

Interpretation and memory are motifs of Martha Casanave's two series of photographs from the USSR. One can't take a photograph without its being an act of interpretation, and one can't view Casanave's art without its evoking a memory (or metamemory) of the reality it is the art of. But in these exquisitely literate photographs, metaphor (that form of interpretation) elaborates memory, pressing the original under layers of intentionality. It is thus that the images in the photographs from the "Out in the Cold" series are overlain by the strangely (and sometimes even horribly) realistic though unexpected colors imposed on them. In one a bridge extends from the far side of an embankment stained by previous tides of blood. In others lurid skies harbor and condense a violence immanent in the landscape or in its history. The colors, in this case, parallel the original light, but they occupy a different time frame. It seems, in fact, to be a theatrical time frame, exactly fitting the scenes, which often are themselves theatrical in their frontality and in their intentions.

The photograph of the toasting couple, for example, depicts a theater of hospitality. And since it is a theater of hospitality, it implies the audience. In this photograph there is a formal reciprocity which makes the presence of the third person (the audience) central to the scene, and that third person is not only the viewer, me, but the photographer, behind whom I'm watching. Meanwhile, within the photograph in a photograph on the wall, there appears to be an image of the photographer seen from behind—or one could call it an afterimage— which suggests that she is departing at the far side of the scene. Her presence in the photograph thus unsettles the scene. Simple hospitality is transformed into a series of overlapping and shifted views of viewing. Indeed, the world of these photographs is determined by conflicting logics, presenting scenarios of opinion and a particular non-Western excess, where dramas replace commodities in the manifest social economy.

But display in this sequence of photographs is expressive also of an eroticism that underlies the milieu. The tension between blatancy and secrecy, between what is offered and what is withheld, are components of desire in its many manifestations. Regarding them, we see something simultaneously alien and familiar, on the other side of the mirror into which or across which we are looking, at an other. Politically, for all or most of our lifetimes, Russia has been just such an other.

We have had a great desire to know Russia, which, it seems, ultimately we can't know, as if by definition. The violence, the irony, the voluptuousness, the seductiveness, and the discretion of the images in these photographs are overwhelming and brilliantly unsatisfying, so that one wants to know more, to go back there.

The dreamy images in the pinhole photographs are both produced by and buried under layers of time—each

photograph emerges out of the extended time required for an adequate exposure of the film in the camera and depicts a city losing itself over time in the mists of a northern swamp, an historic city in atemporal light.

Modern Leningrad, like early St. Petersburg, because of its northern location on the Gulf of Finland near the Baltic Sea and close to Lake Ladoga (the largest lake in Europe) and because of the Neva, Moika, and Fontanka rivers, the Karelian swamp, and the system of canals on which it is built, seems always either to be evaporating into some future distance or to be emerging out of the past. The play of time, and thus of light, which is quintessential to Casanave's "Winter in Leningrad" images just as it is to the very making of a photograph, produces elusive or ephemeral images of "there," as if memory were a characteristic not of perception but of light. These are perhaps images of time and space without history, or places out of time, arrested by the almost scientific scrutiny of the intuition. Over the fluid grillwork of its gates and bridges and its porous escarpments, the city draws us into its distances, the eye pursuing perspective lines that evanesce without arriving at their vanishing points. What's fragile takes on form, and what's solid evaporates. In the refracted light and against the saturated facades, it is hard to determine whether the vanishing point might be near or far and whether one is looking into time or space. In fact, the logic of perspective is reversed in these photographs, since, in a sense, the "vanishing point" is their beginning point: the vista pours out from the pinhole.

Martha Casanave's travels in the Soviet Union began over twenty years ago, and although these two series of Russian photographs are the most recent of the works included in this present volume, the influence of those travels is evident generally in her perceptual palette. The paradox that her photography embodies, with its frontal ambiguity and sensitivity, presents us with an aesthetic challenge which is provocative and thrilling.

PORTRAITS

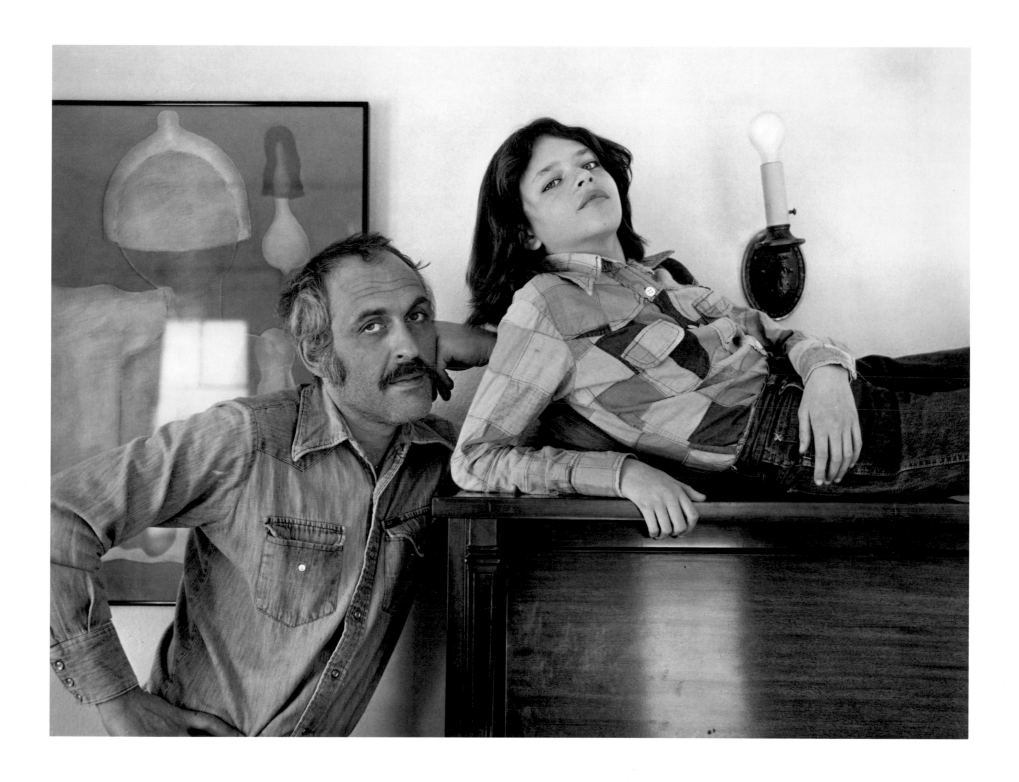

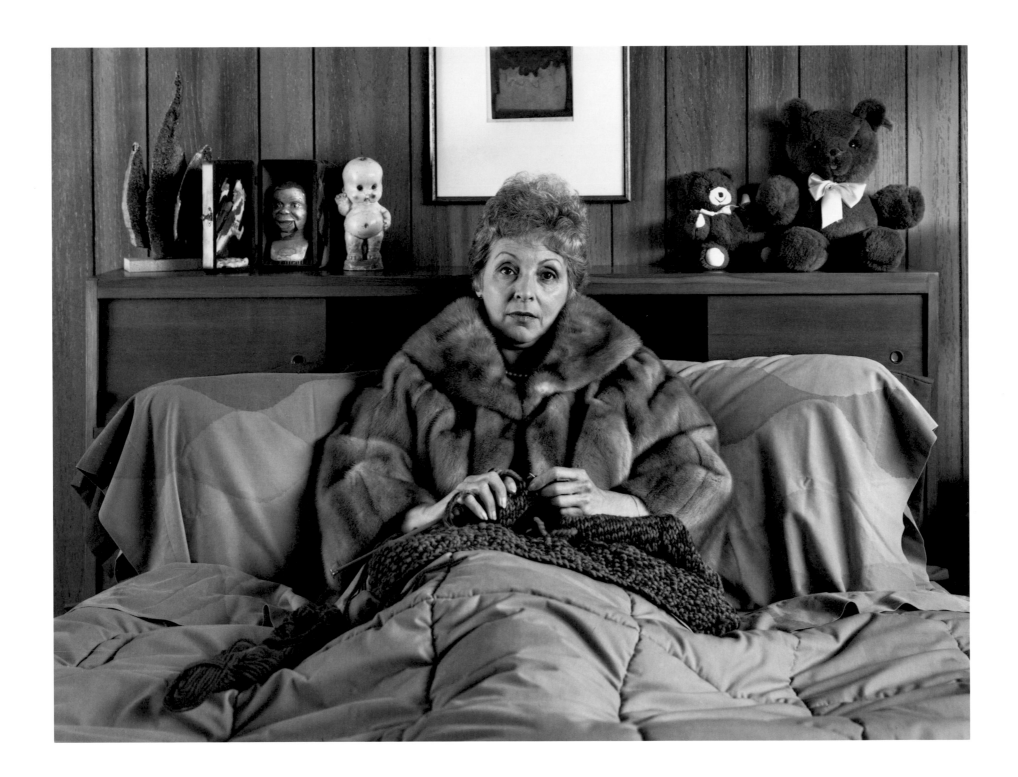

16.

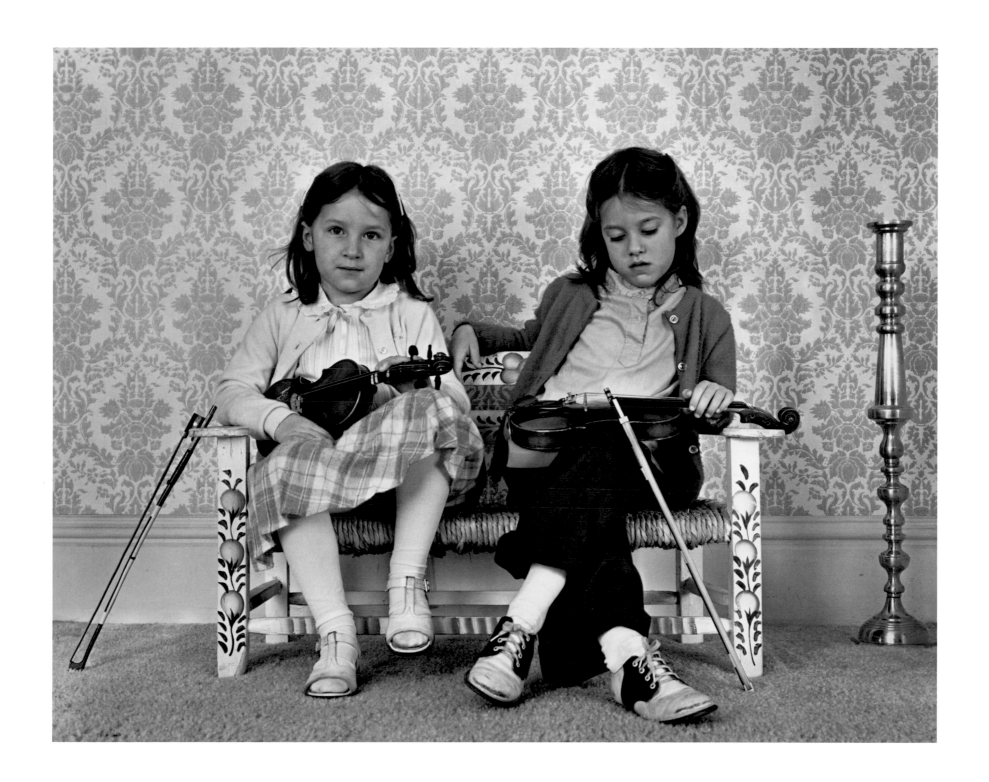

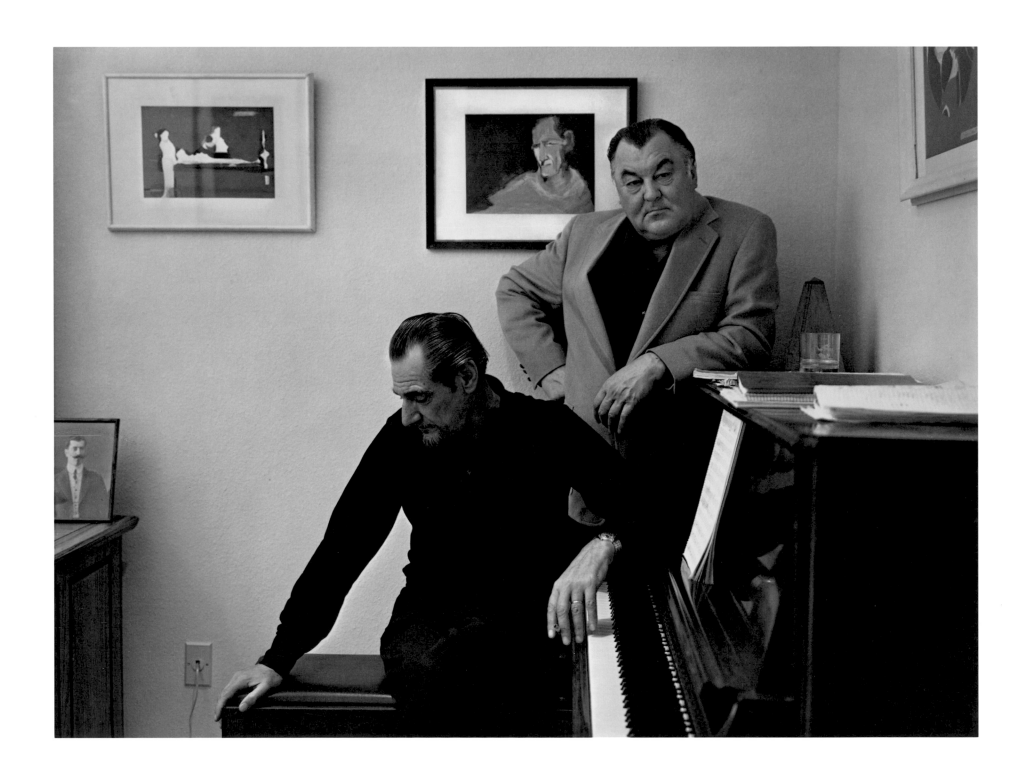

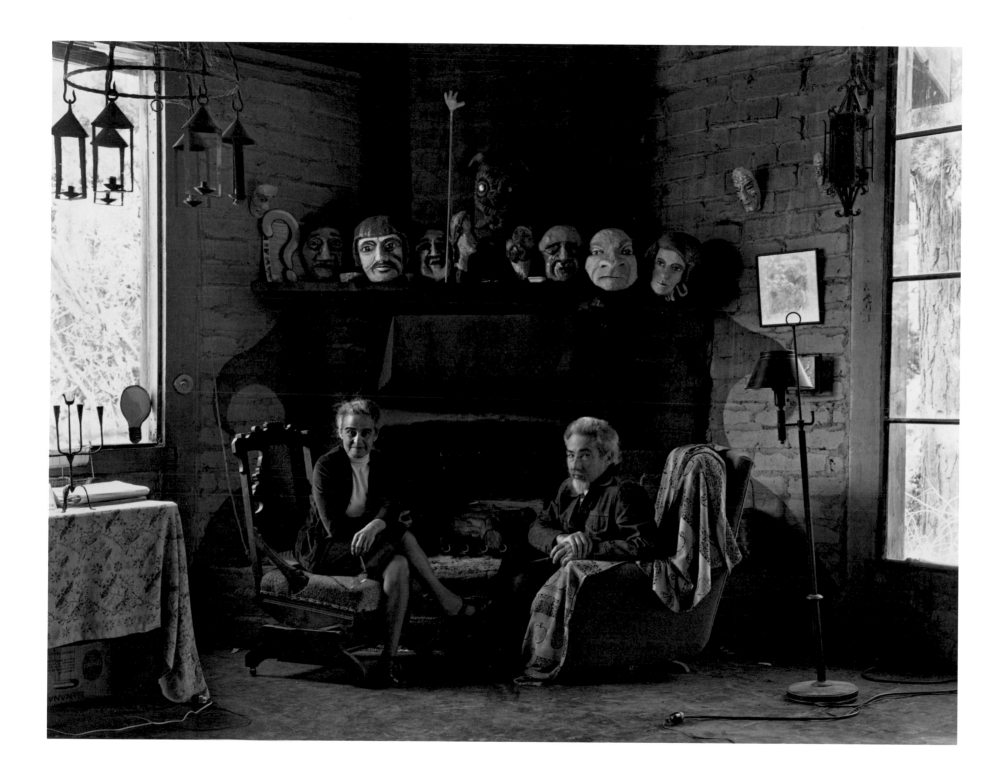

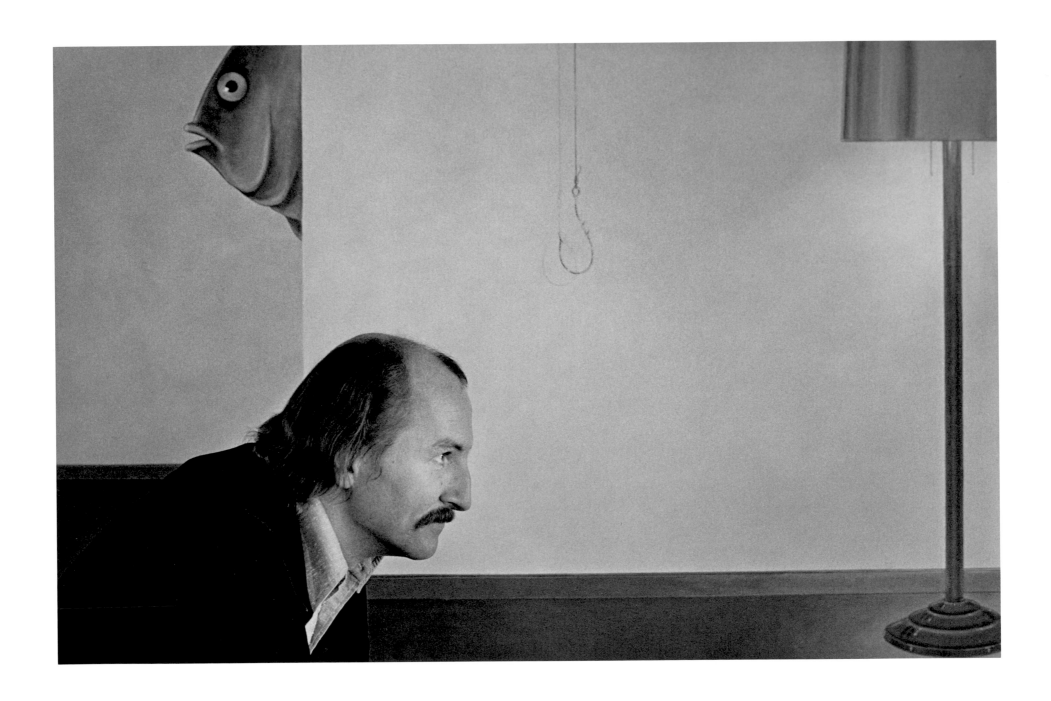

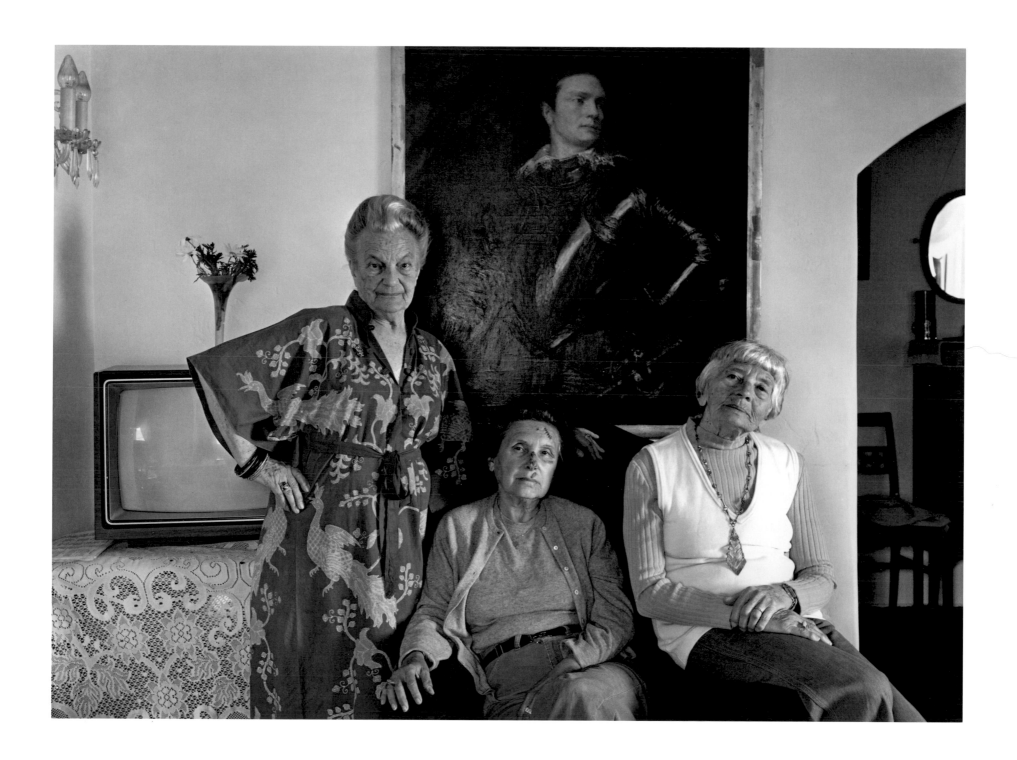

NUDES

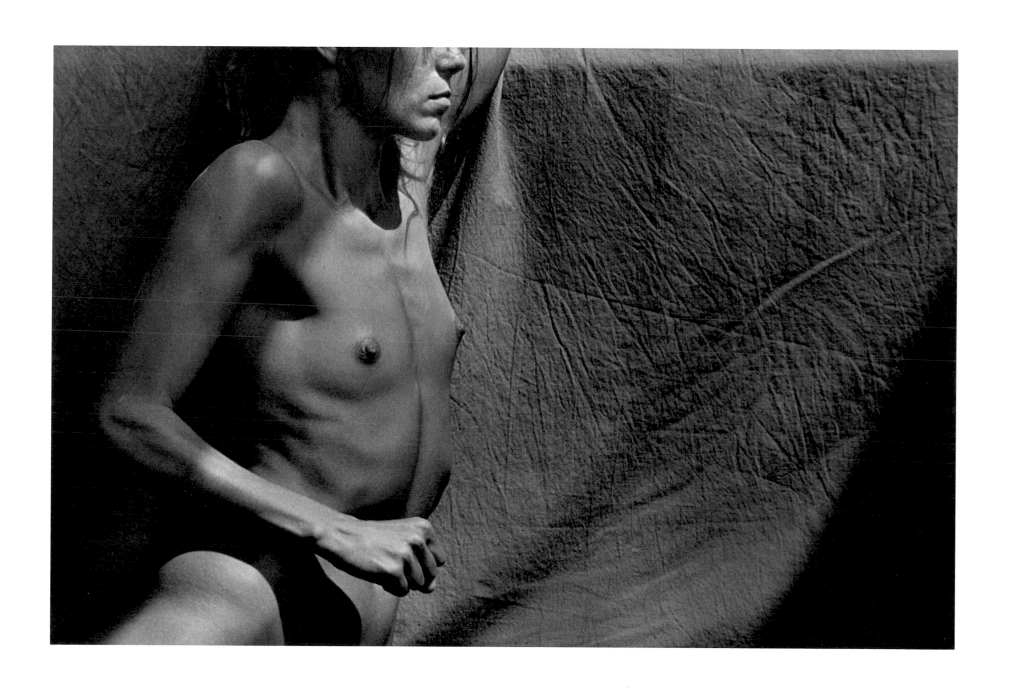

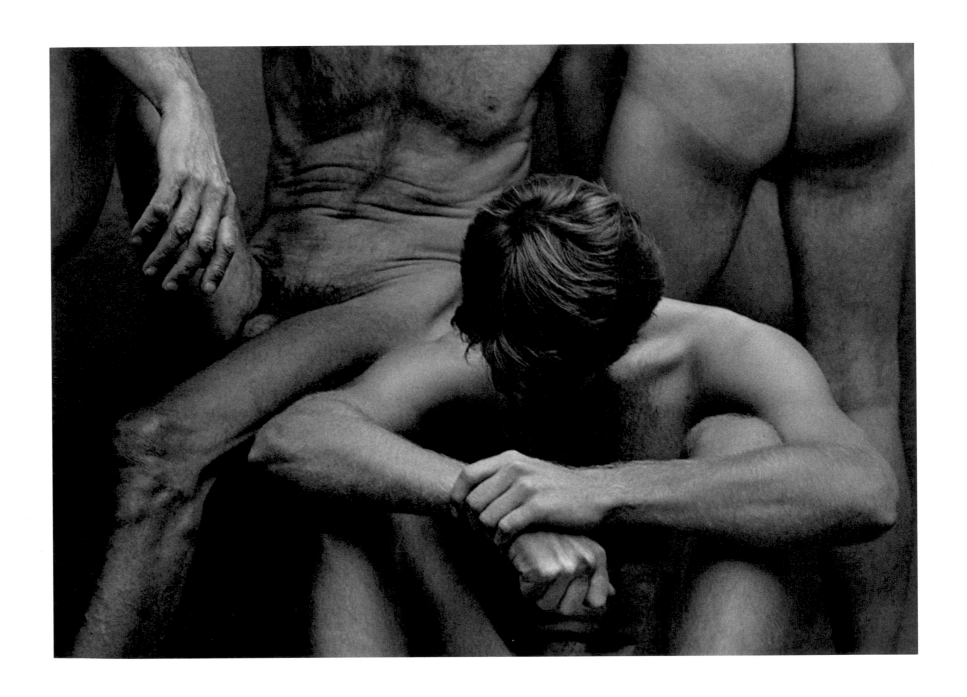

24.

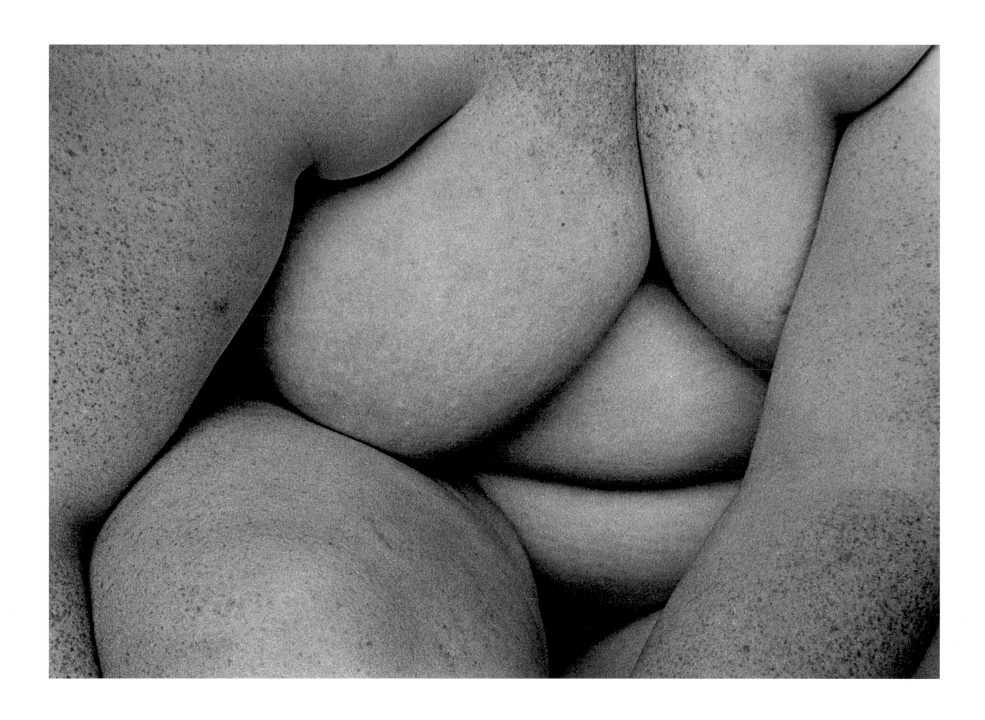

25.

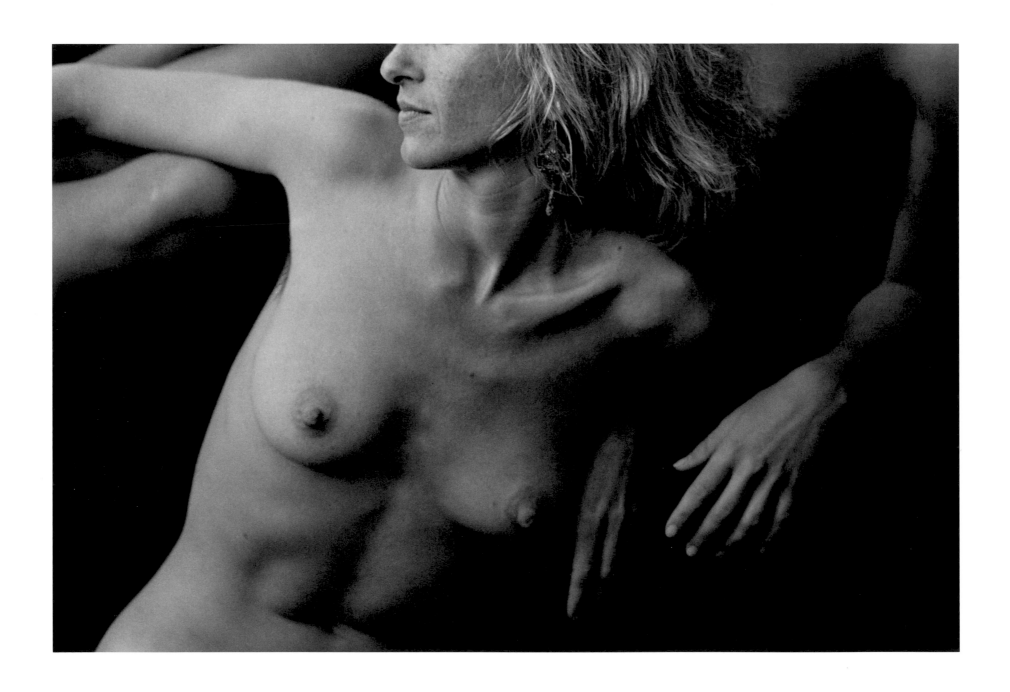

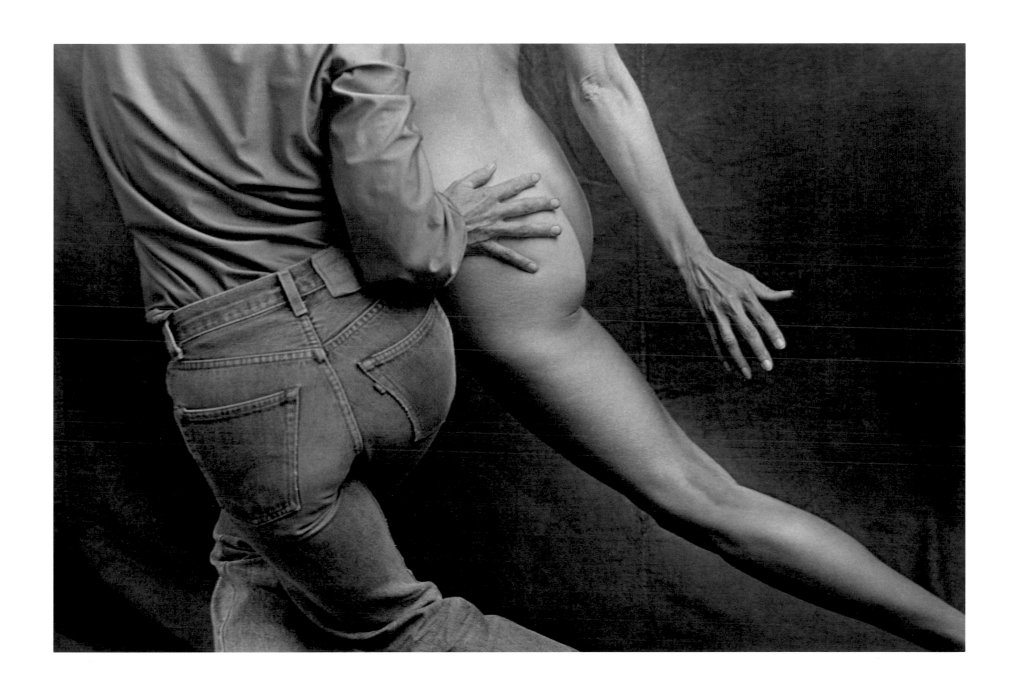

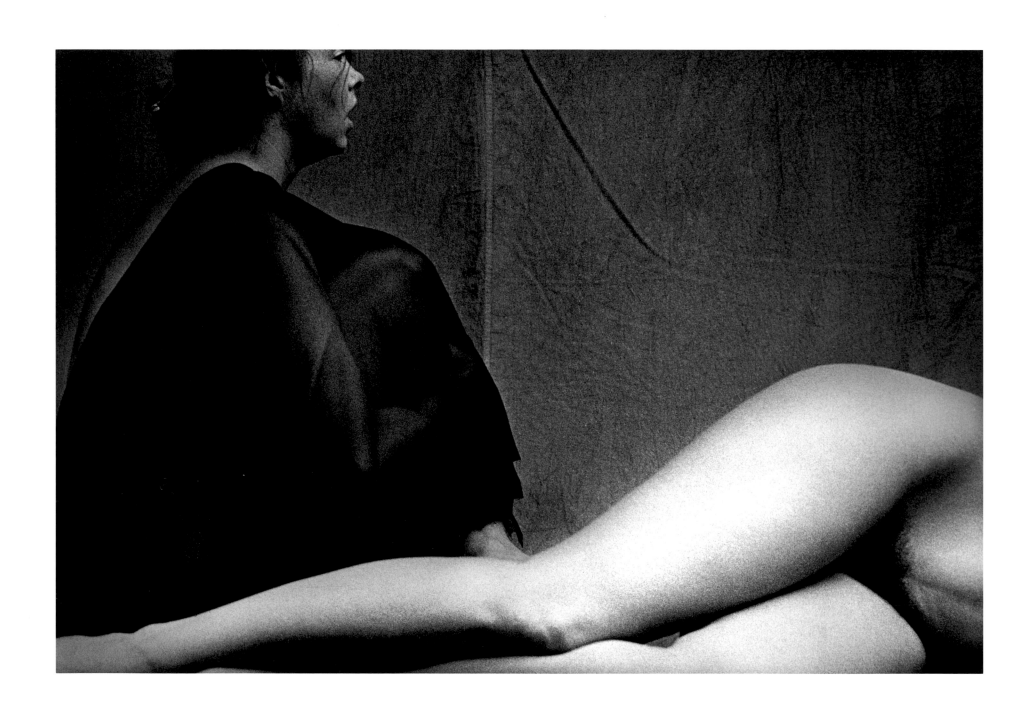

28.

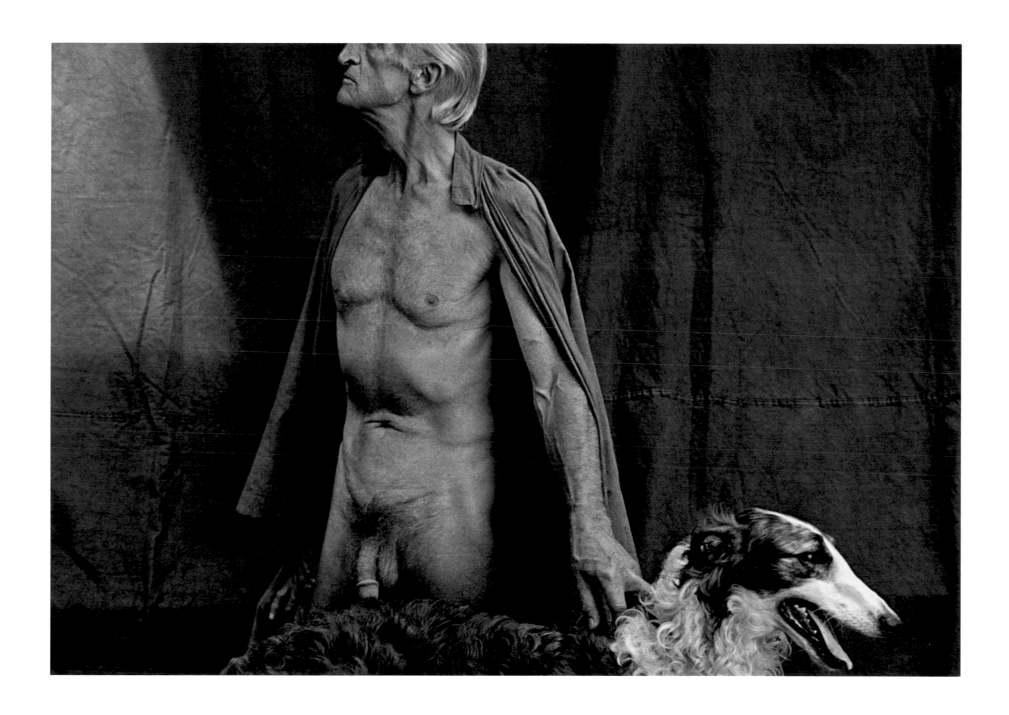

29.

NARRATIVES

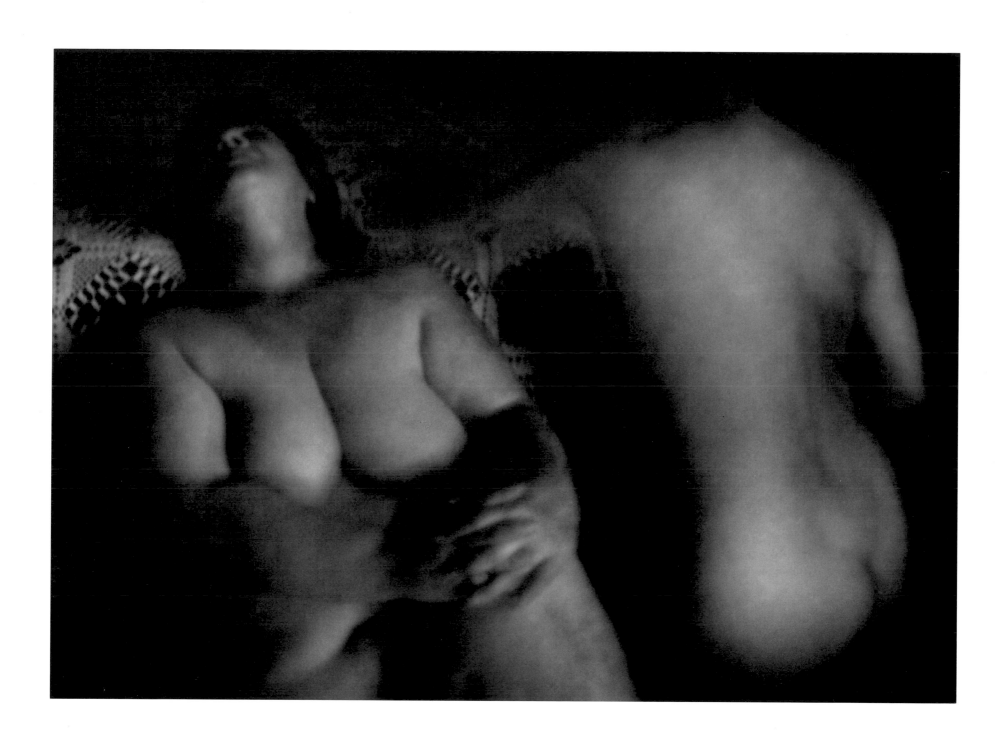

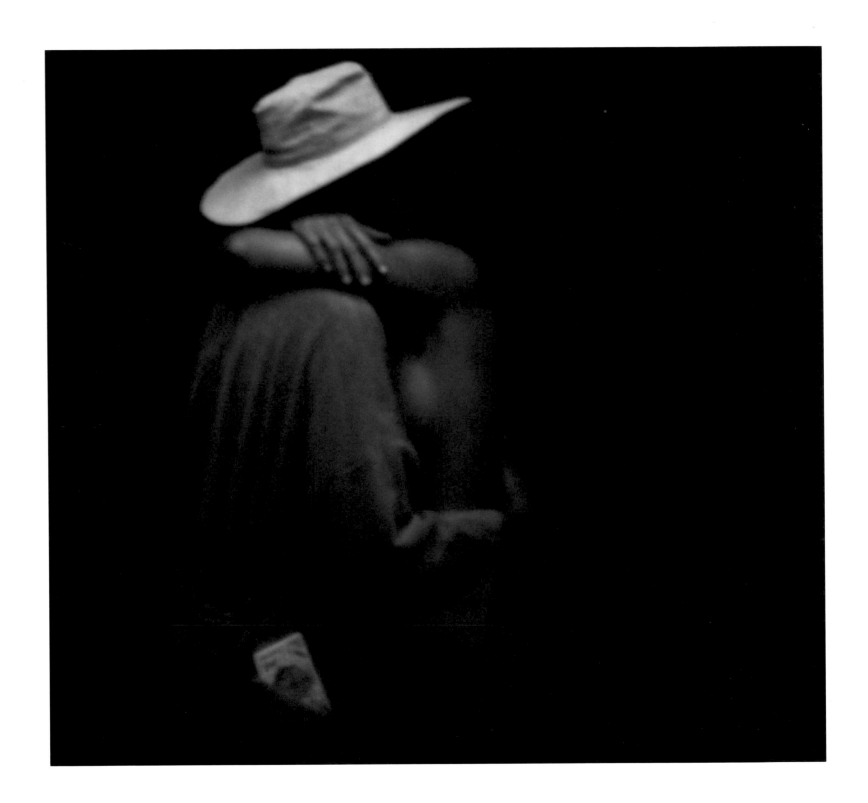

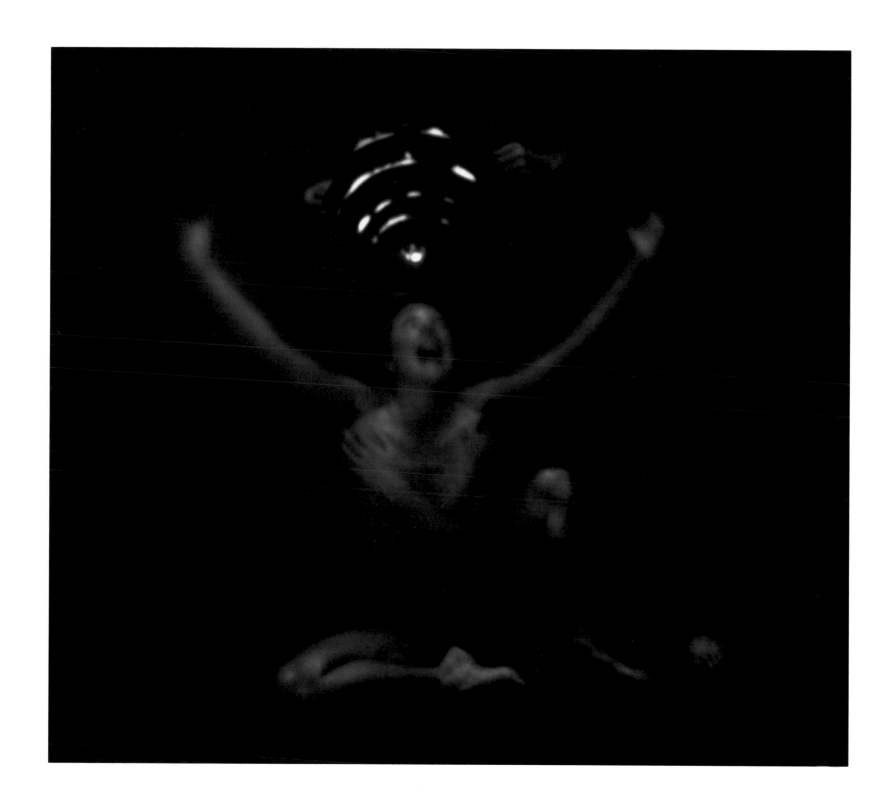

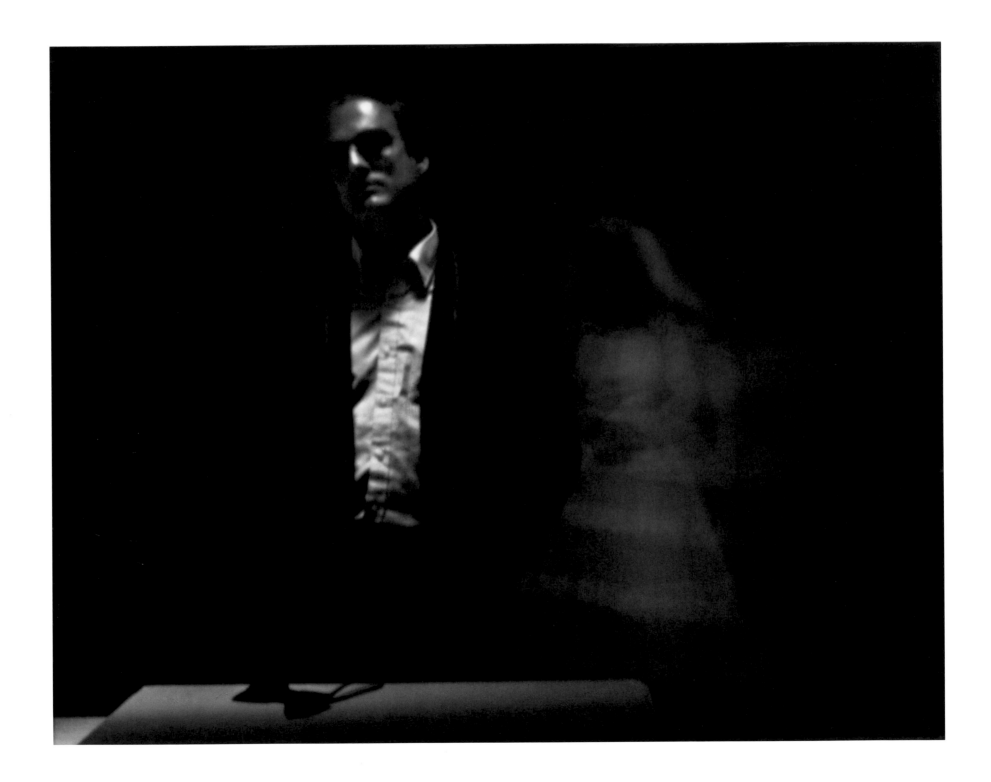

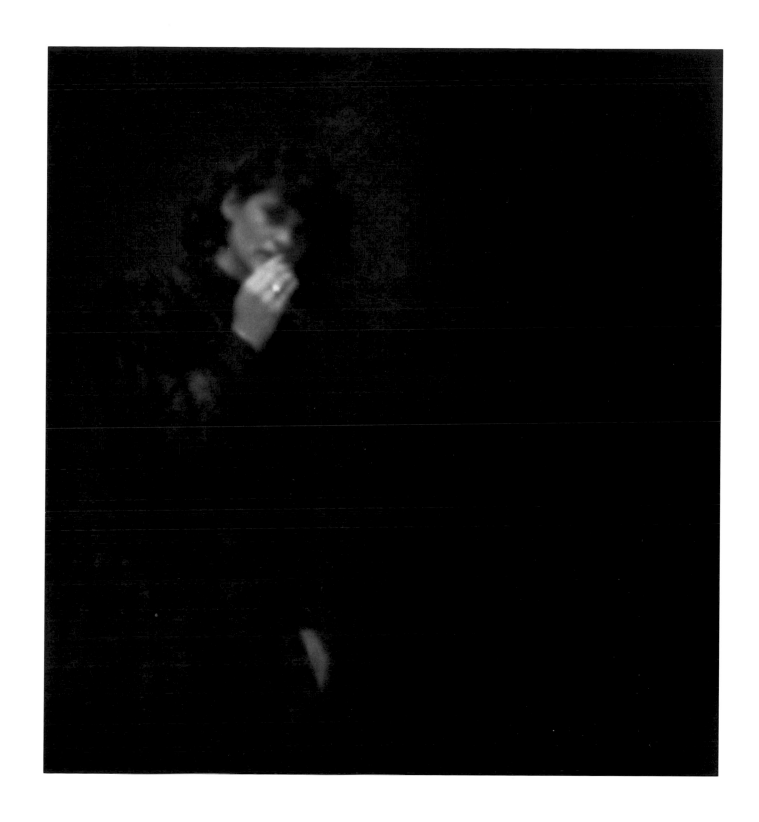

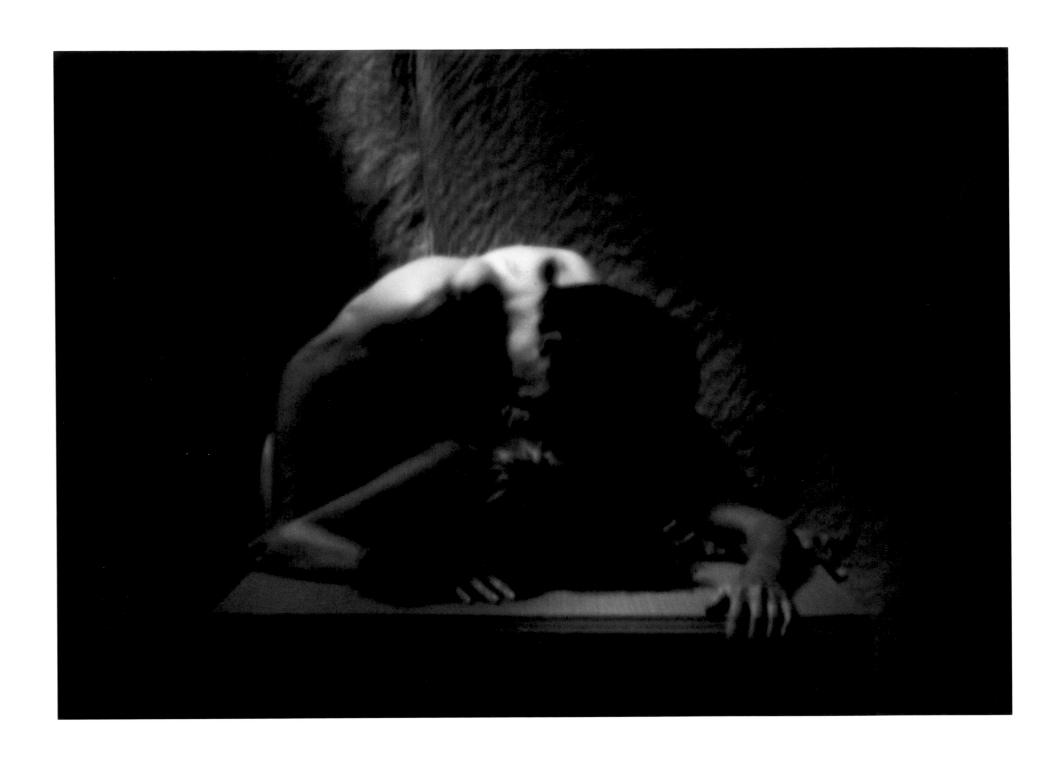

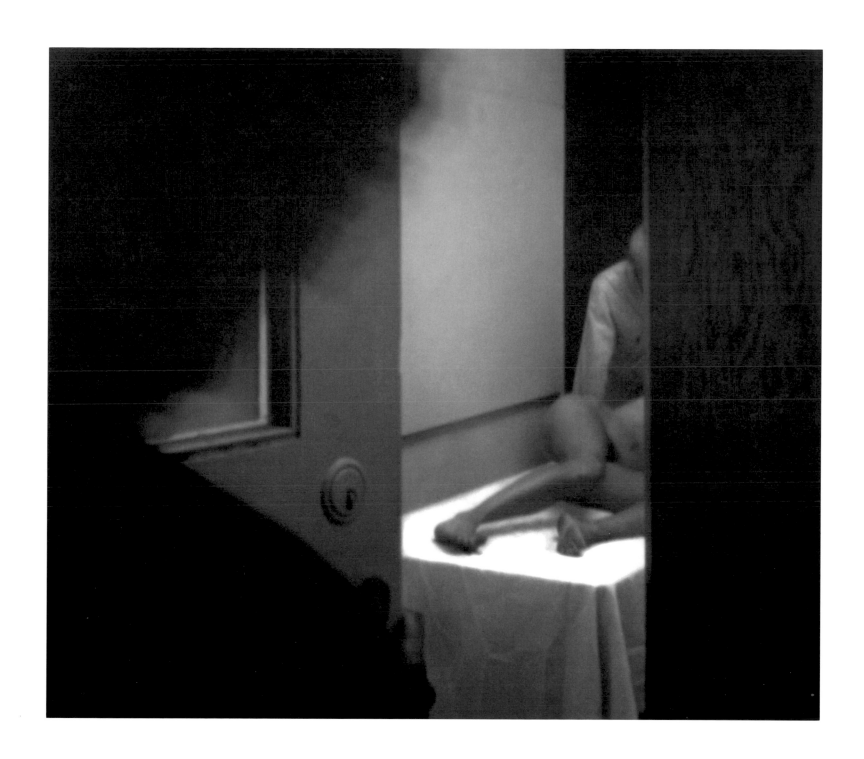

OUT IN THE COLD:
AN AMERICAN
IN THE SOVIET UNION

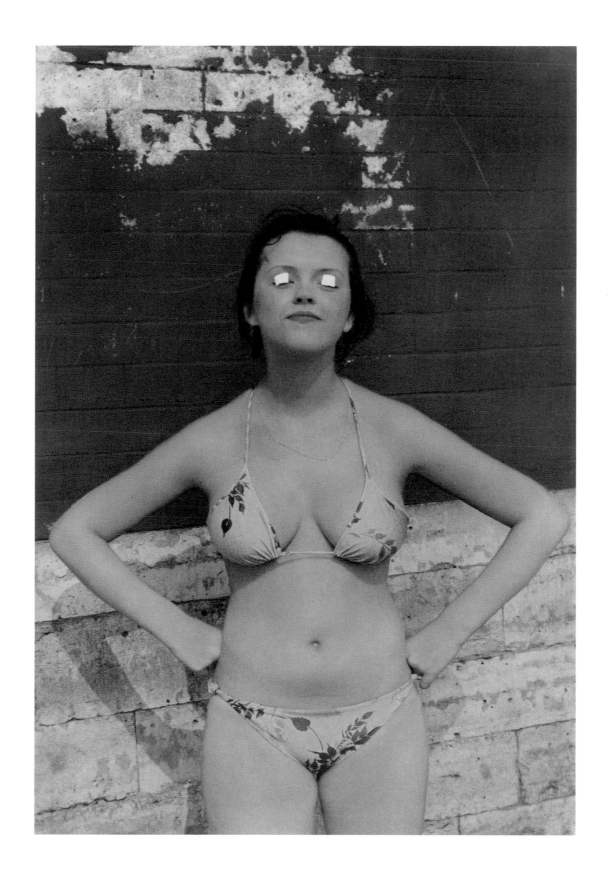

39.

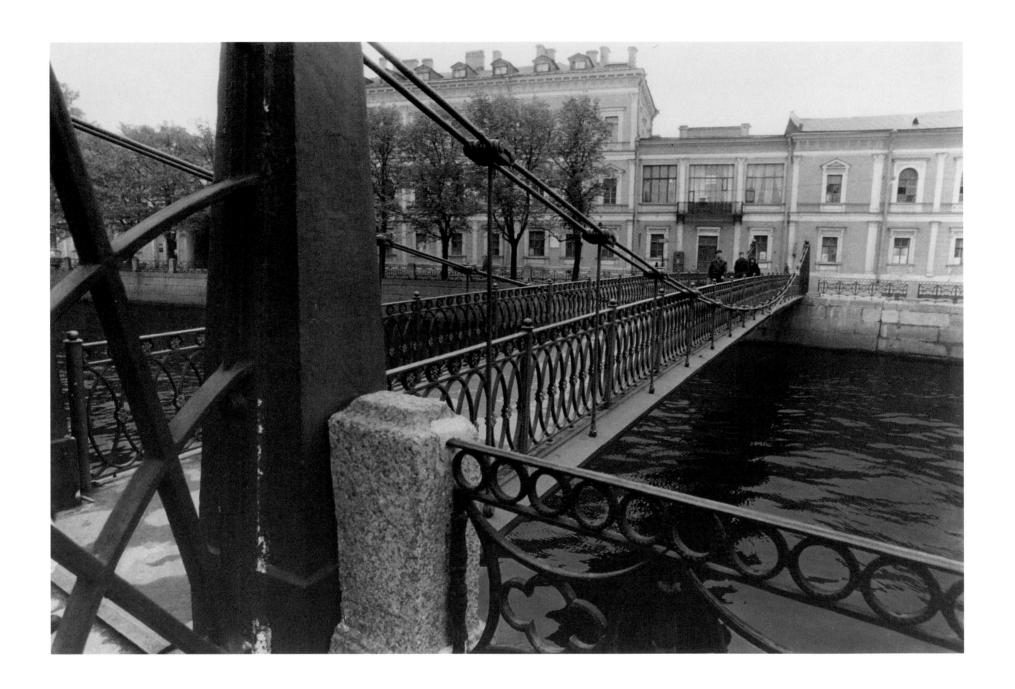

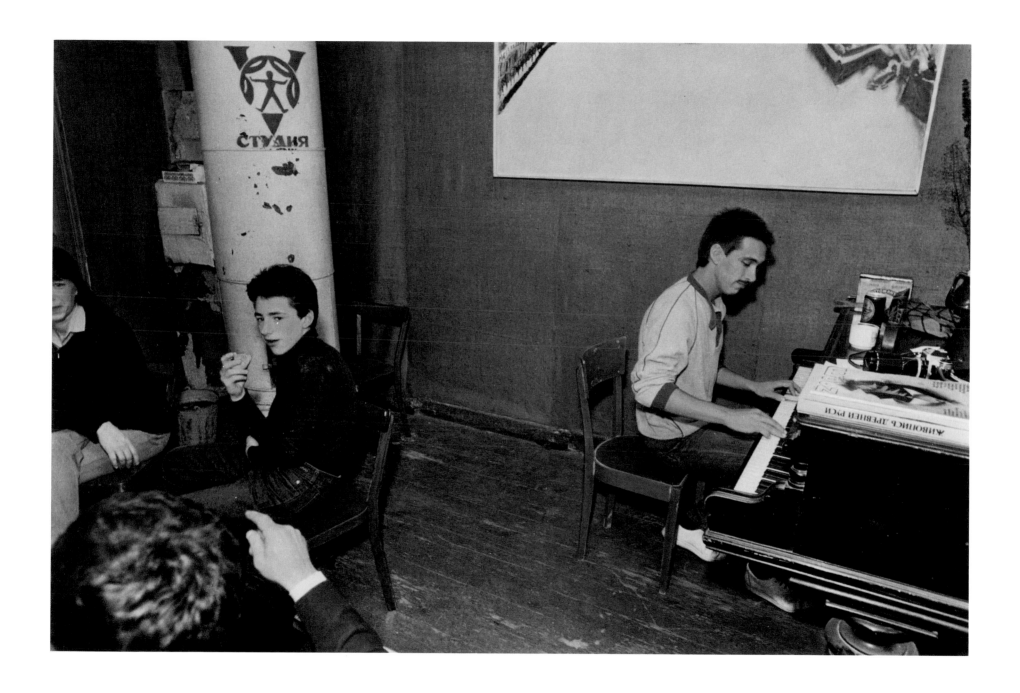

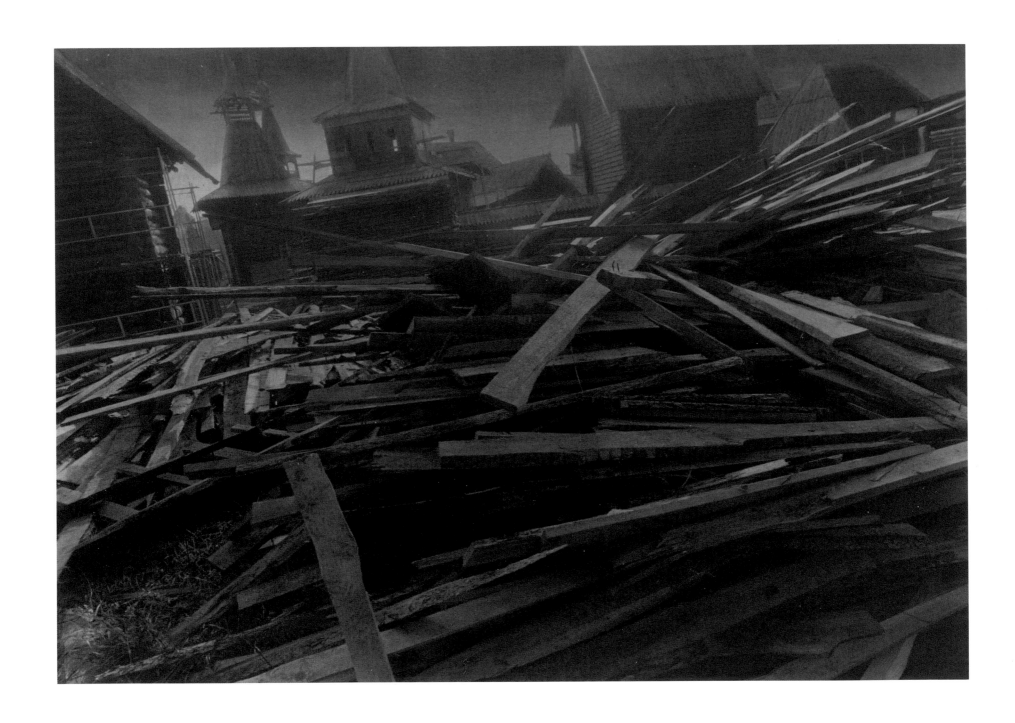

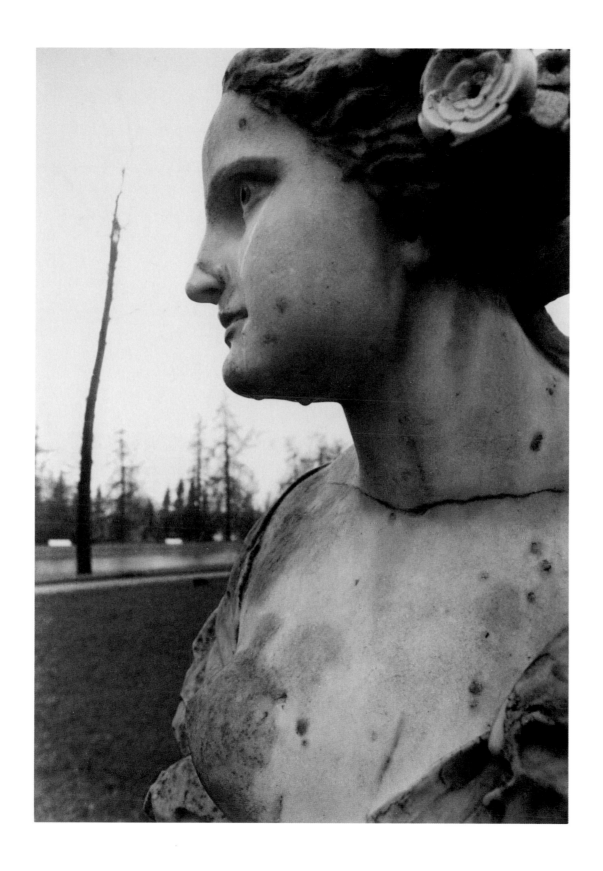

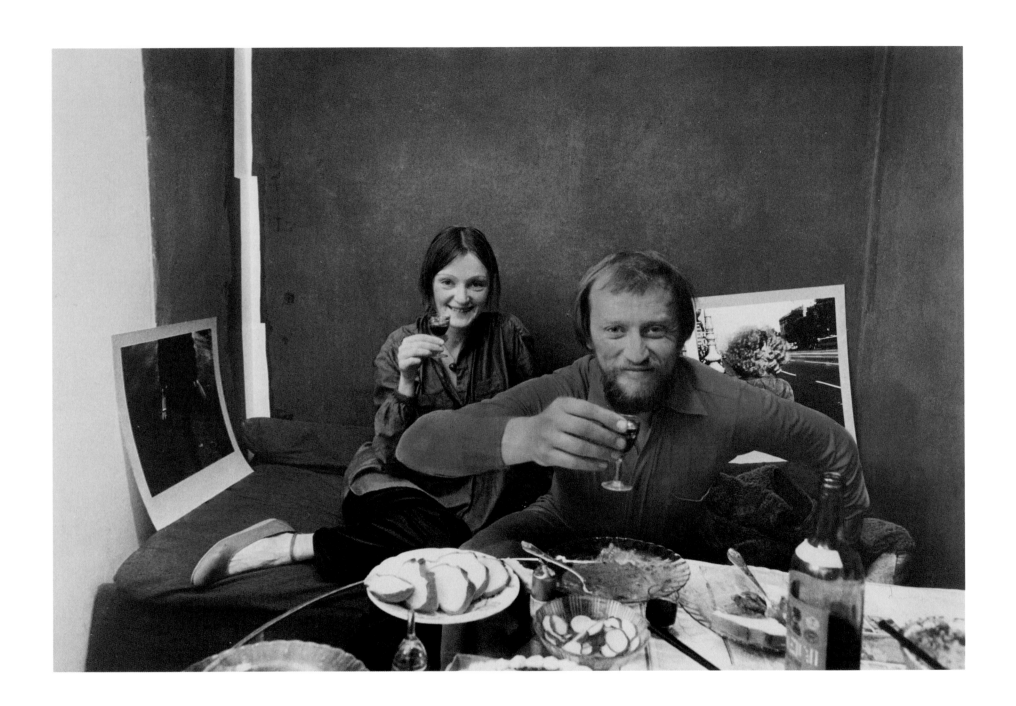

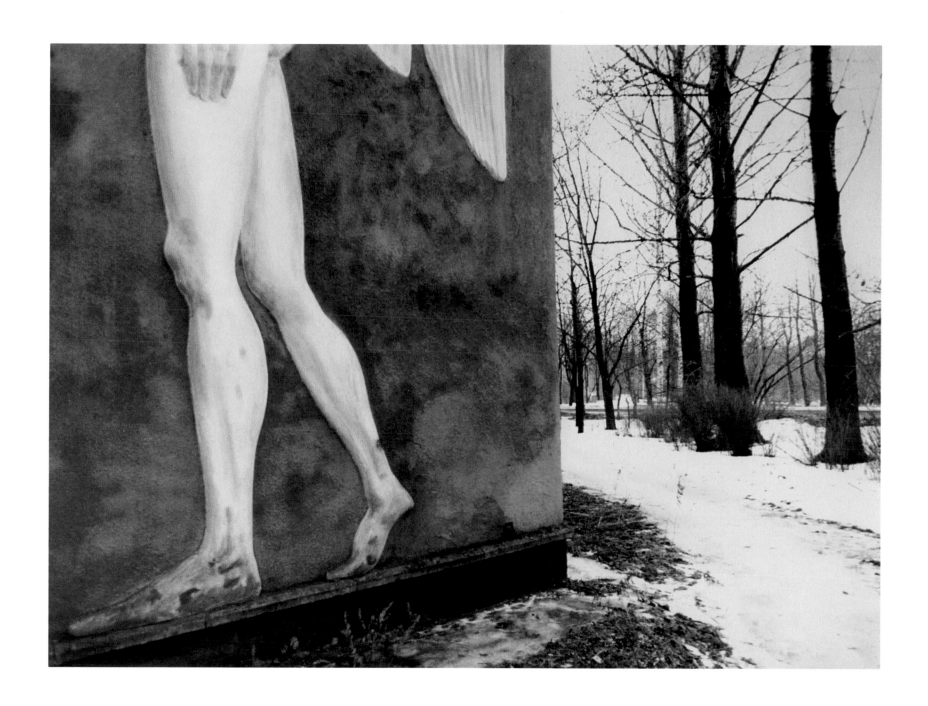

LENINGRAD IN WINTER

47. *The Neva, 1988*

48. *House Where Dostoevsky Was Arrested, Voznesensky Prospect, 1988*

49. *Children, Solianoi Garden, 1988*

50. *Griboyedov Canal, 1988*

51. *Lion, Mikhailovsky Garden, 1988*

52. *The Fontanka, 1988*

53. *Leaning Trees, Mikhailovsky Garden, 1988*

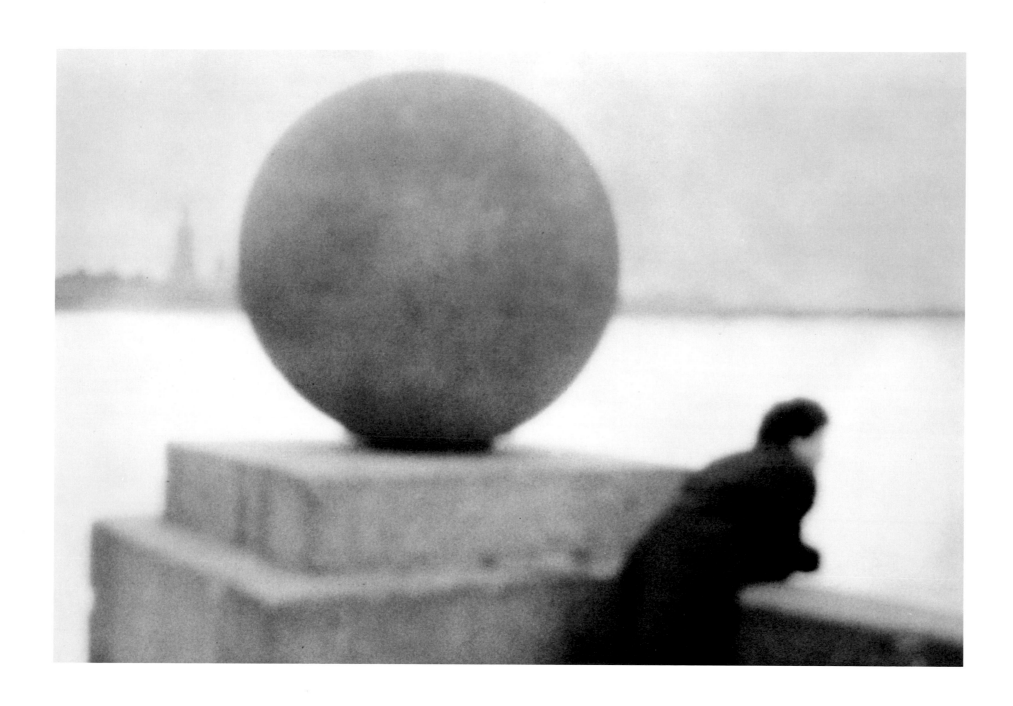

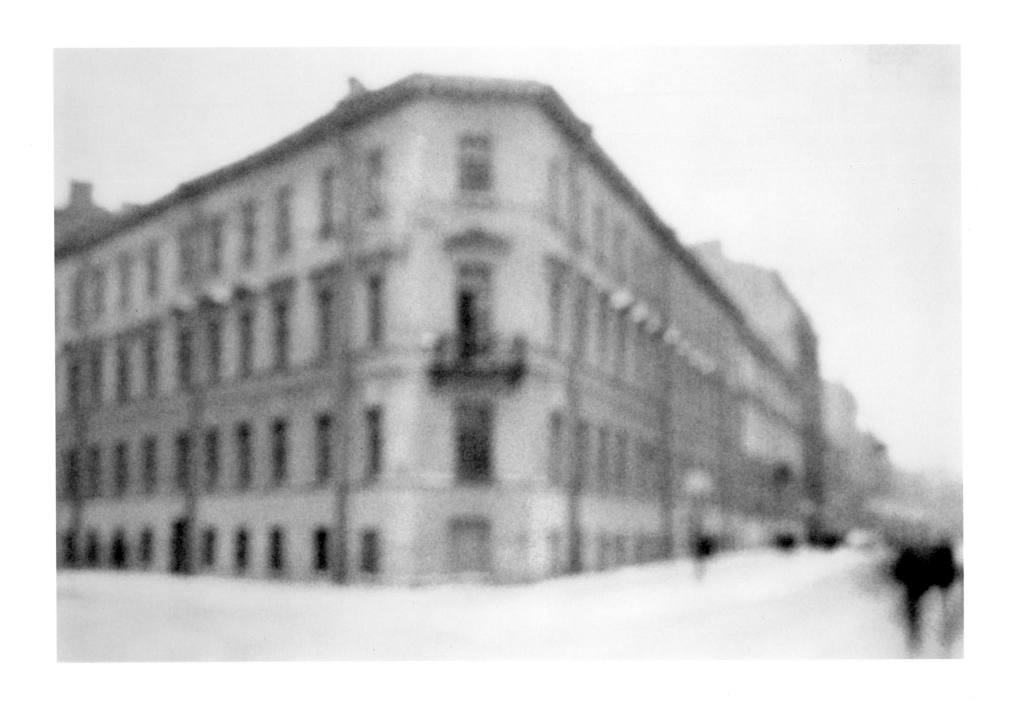

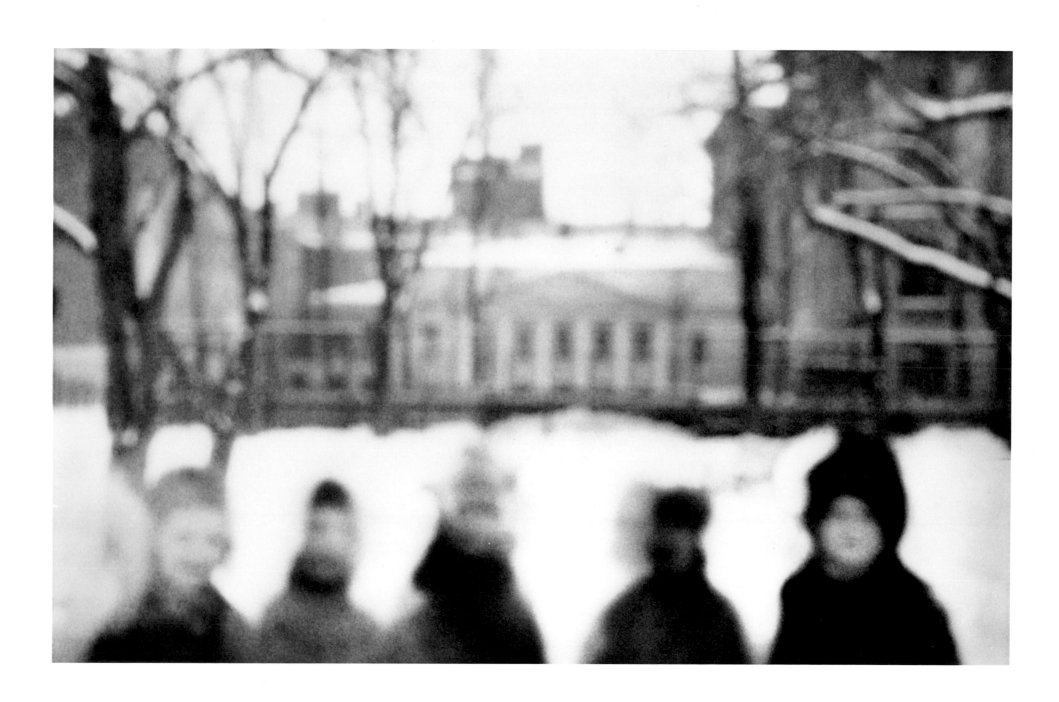

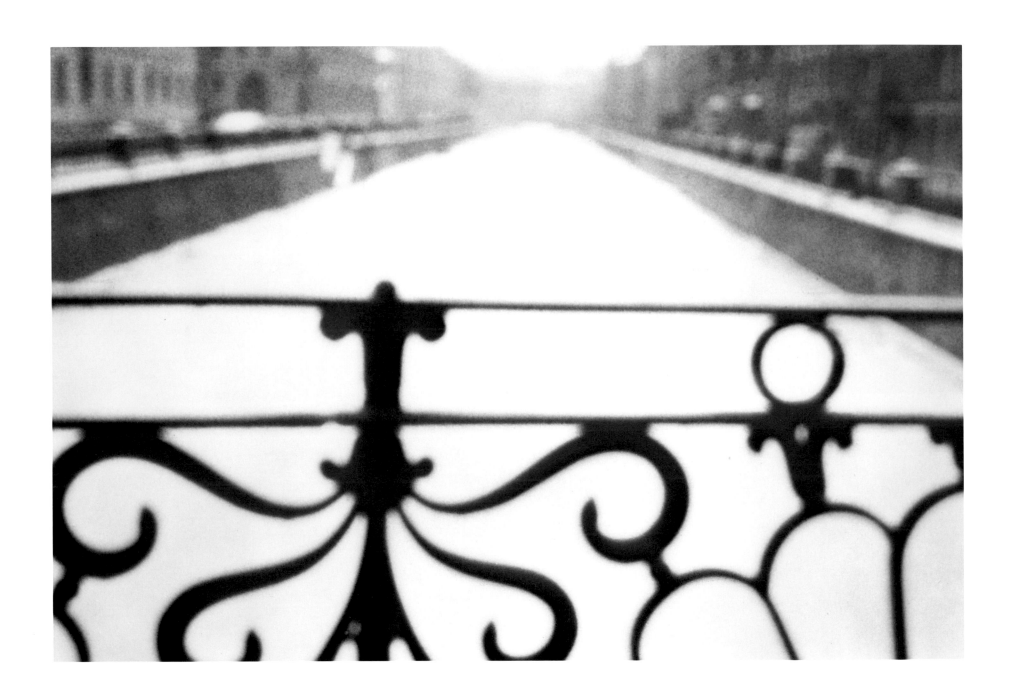

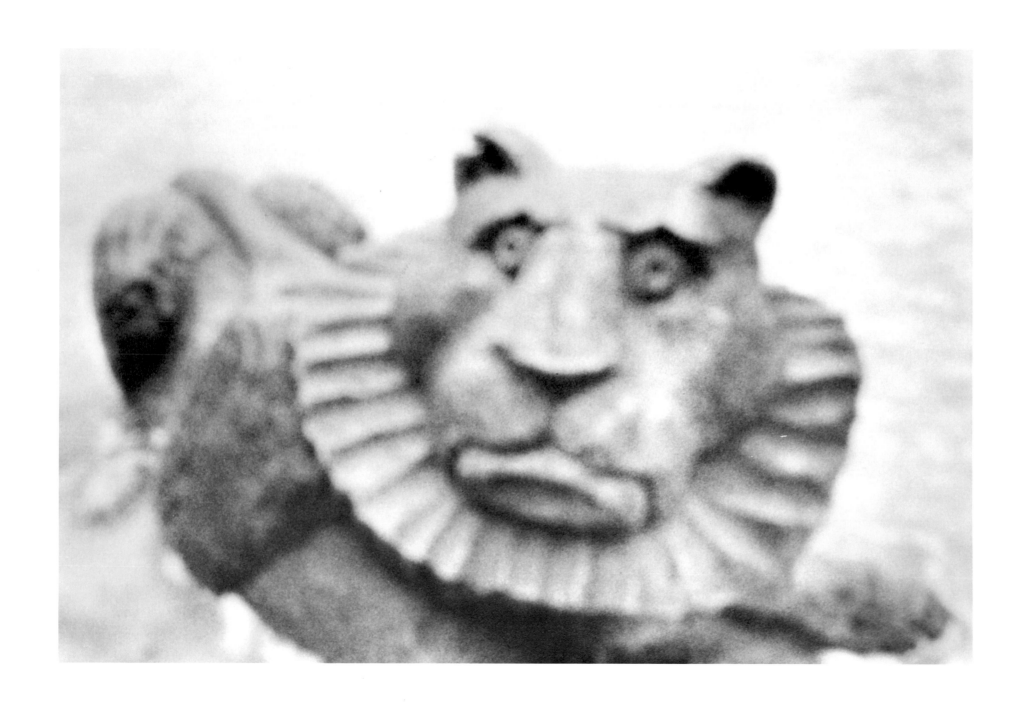

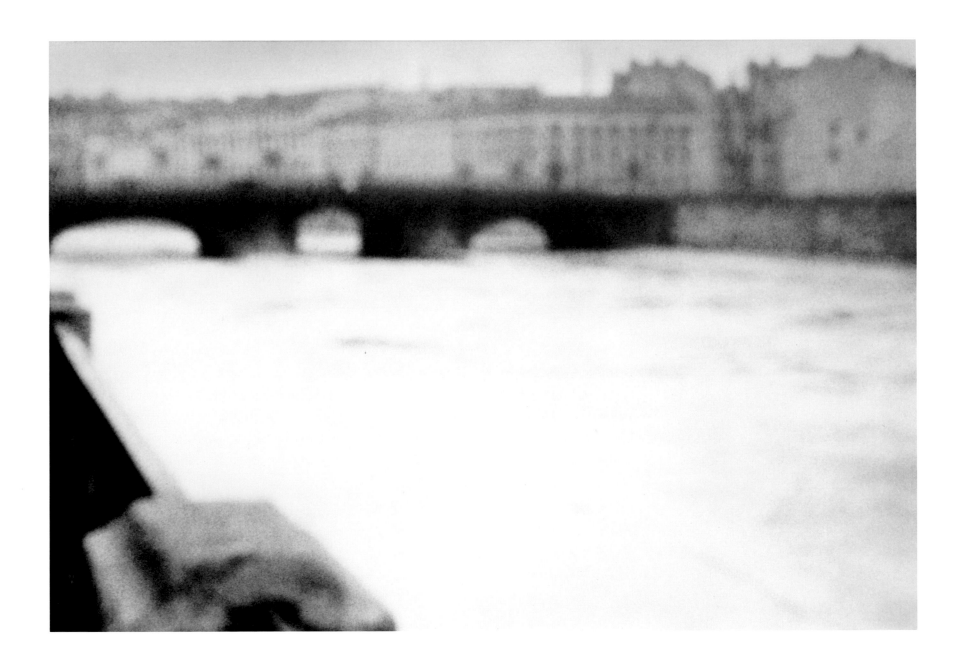

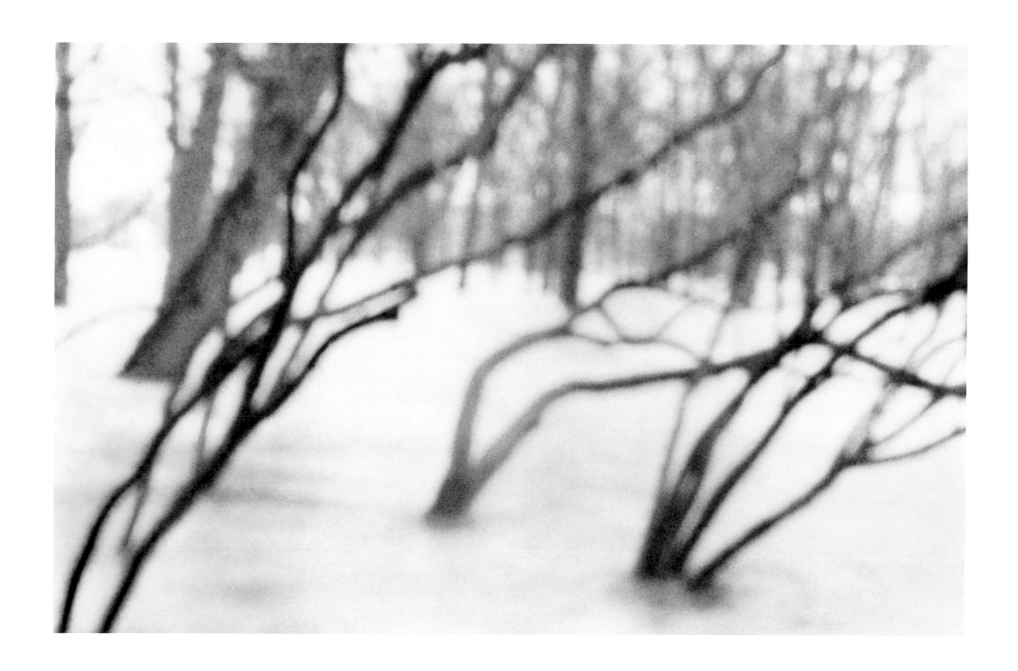

AFTERWORD

by Eelco Wolf

I MET MARTHA CASANAVE some 13 years ago in New York. She had arrived from the West Coast on one of her annual pilgrimages to view and be viewed.

Don Leavitt, a contributing editor to *Popular Photography* and a friend of Martha, was aware of my interest in discovering and assisting relatively unknown, promising photographers. At that time, I saw thousands of photographs, hundreds of portfolios annually, but it was unusual that work reached, inspired, shocked beyond the routine. My first rendezvous with Martha happened to be such an occasion.

Although the tonality of the work she showed me reflected an overriding quality I had rarely seen—brooding portraits, printed with great force and character—one piece in particular challenged me.

It showed the profile of an artist in the bottom left corner. A stark, austere shape of a lamp—the shade cut at the top—dominated the right side of the image. A drawing of a monkfish head in the upper left corner dissected the right side of the image. The fish head and the man's head stared in opposite directions—reverse osmosis. A fishhook delicately balanced the image, the subtle shadow of the hook implying double meaning, double entendre. The eyes of the fish were alive.

This was not just a photograph, but, rather, a surrealistic tableau, a pencil drawing, a soft etching.

Since that first meeting, I have followed and supported Martha's career with great interest and extreme satisfaction. In the process, we have become the best of friends, comforting and coaxing each other through hard times. I have watched her grow, seen her work become stronger, more focused, more intense—from her portraits, her nudes, her pinholes, her series of Leningrad, to her fascinating explorations of color-painted black and white photographs.

In her quiet, understated way, Martha goes about doing what she does best—observing—no—penetrating the essence of her surroundings: faces, skin, relationships, situations, forms; recording, constructing, manipulating, recreating, moving from reality to fantasy and back to reality larger than life.

"Out in the Cold" I find her most fascinating, the most disturbing, the roundest body of work—charged with awesome electrifying polarity of intellectual sensuality, passionate wit.

In it, she challenges not just the viewer, but foremost herself—the voyeur. It represents the breakthrough she deserves and has sought so long. And photography will be the better for it.

The publication of this book was supported by Agfa Corporation

Designed by Catherine Waters

Text set in Monotype Bembo by Michael and Winifred Bixler

Display set in Michelangelo Titling by Finn Typographic Service, Inc.

Tritone negatives by Robert J. Hennessey

Photographs printed on Agfa paper

Production supervision by Gregory Graalfs

Color separations and printing by The Nimrod Press

Bound by Acme Bookbinding Company, Inc.